In memory of Allan, who died, sadly,
before this book was completed - *M.H.*

First published in Great Britain in 2000 by
Frances Lincoln Children's Books, 4 Torriano Mews,
Torriano Avenue, London NW5 2RZ
www.franceslincoln.com

First paperback edition published in 2001

First published in the USA in 2000. This paperback edition published in 2006

Distributed in the USA by Publishers Group West

British Library Cataloguing in Publication Data available on request

ISBN 13: 978-1-84507-688-7

Illustrated with mixed media

Printed in China

9 8

DOGS' NIGHT

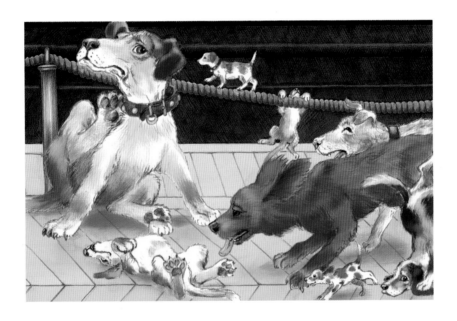

Meredith Hooper

Illustrated by Allan Curless *and* Mark Burgess

with paintings from The National Gallery

F

FRANCES LINCOLN
CHILDREN'S BOOKS

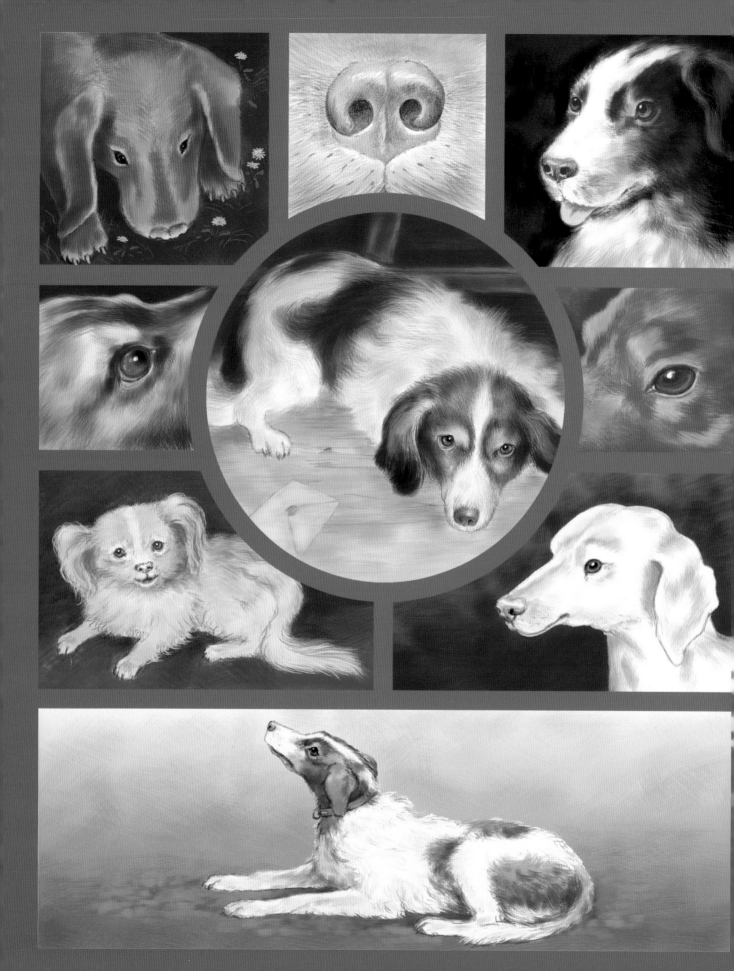

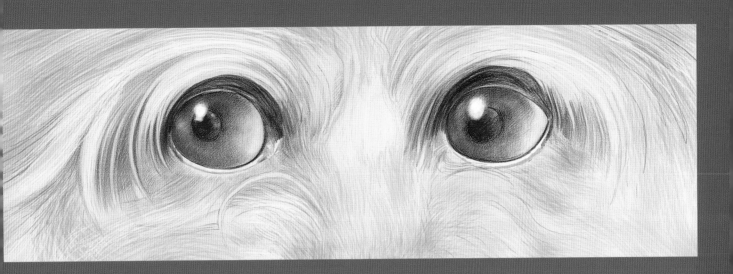

The dogs were excited. Big dogs, little dogs, fat dogs, thin dogs, spotty dogs, plain dogs, noses sniffing the air, ears listening. They were waiting for the moment when everyone had gone home and they had the Art Gallery to themselves. Tonight was Dogs' Night. Tonight was their secret, once a year, special night out.

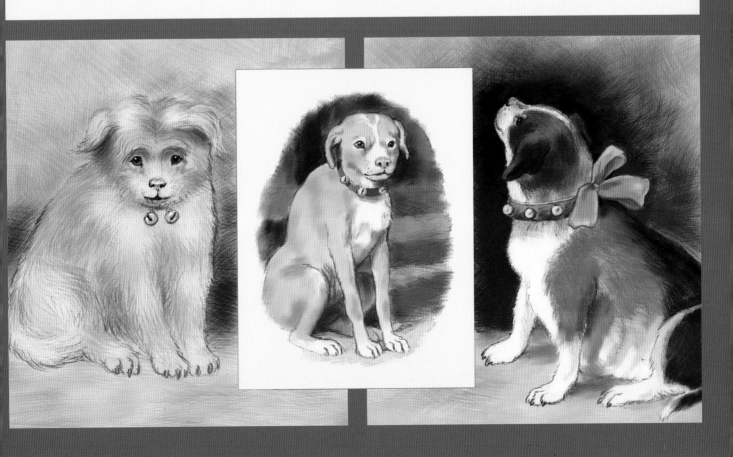

But at the end of the day, the Art Gallery did not close. The guards did not shut and lock the doors. Instead, people came in to the big rooms and had a party amongst the paintings.

The dogs were very cross. It was their night out and the people were in the way. The dogs waited, eyes staring, tails stiff. The people were too busy eating cakes and sandwiches to notice.

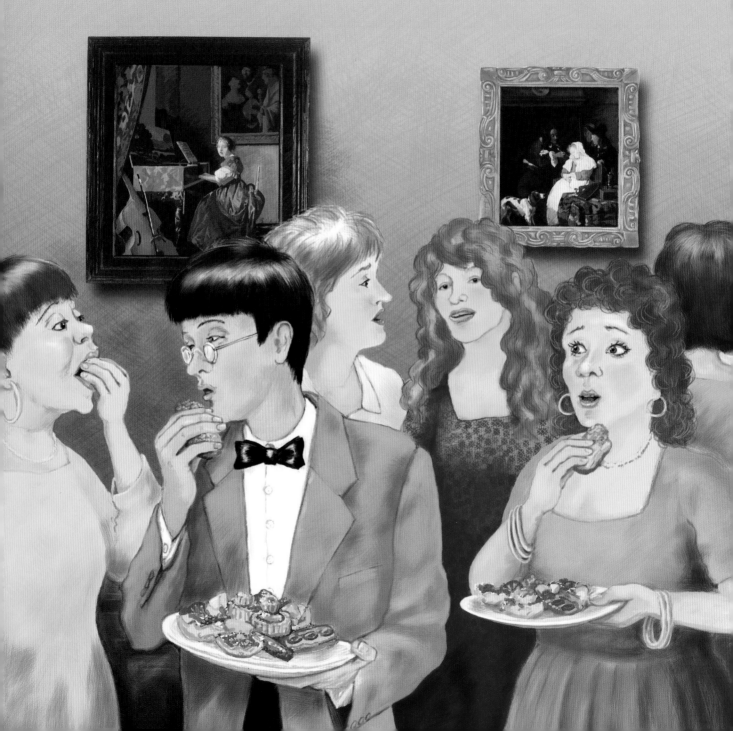

"Guzzlers," thought the dogs, their mouths watering.
Nobody was ever allowed to eat in the Art Gallery.
 At last the people finished their party. The guards shut
and locked the doors. The big rooms were empty and quiet.

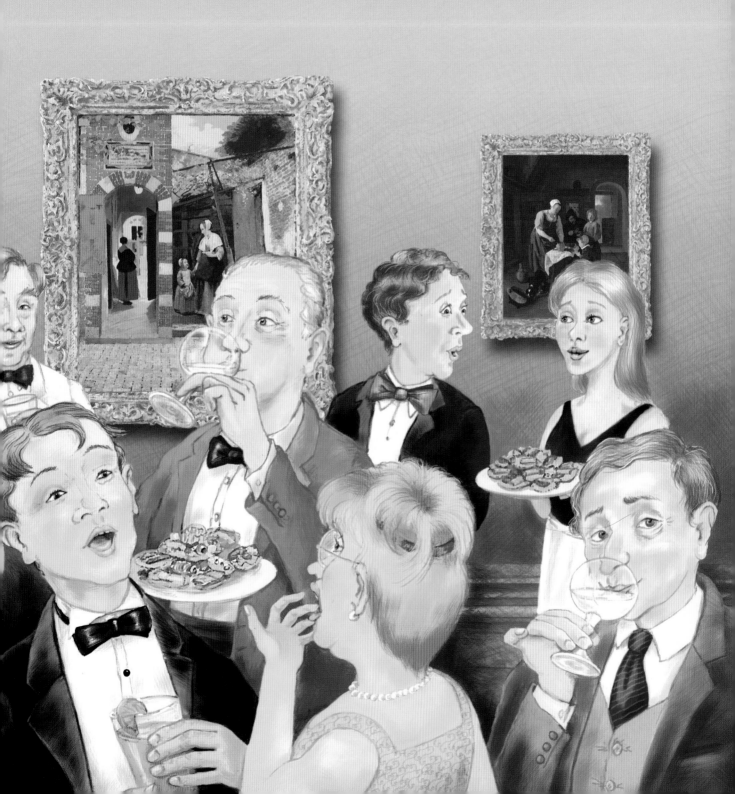

Now the dogs could get out.

Soldiers' dogs and children's dogs, royal dogs
and beggars' dogs, smooth dogs and woolly dogs,
polite dogs and rough dogs, dogs that belonged in houses
and dogs that lived in streets, dogs that sat on knees
and dogs that hunted. All the different dogs climbed
out of their paintings. Their legs felt very stiff.

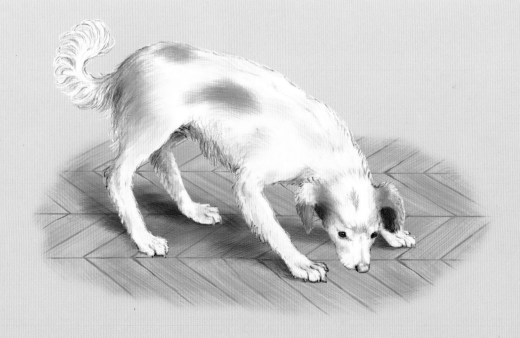

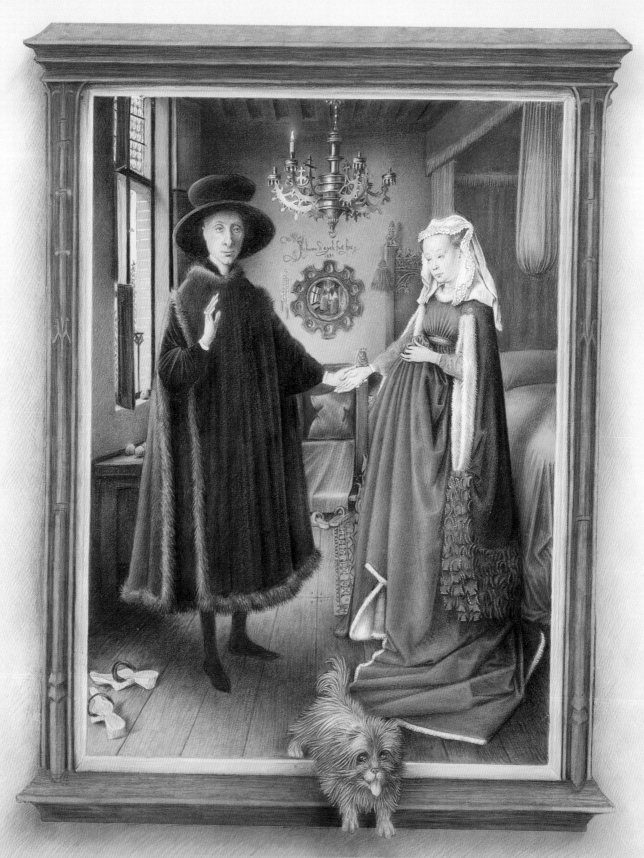

The small, hairy dog jumped down on to the floor,
barking and barking.

The red dog with the floppy ears climbed out backwards.

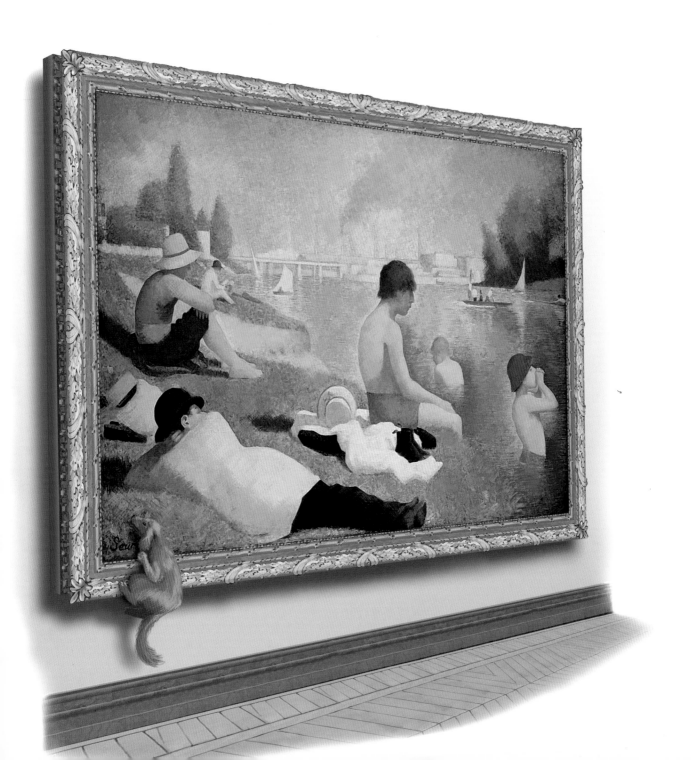

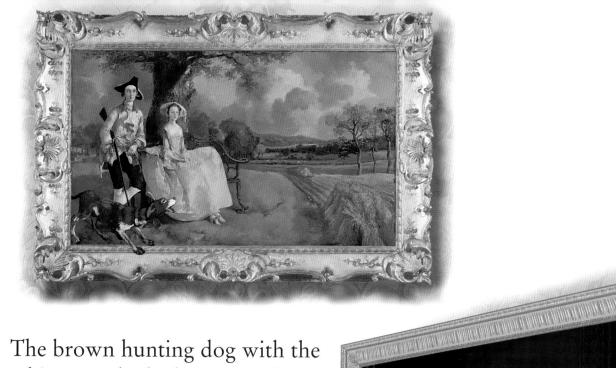

The brown hunting dog with the white nose had a long stretch.

The black dog with the wavy tail had a good scratch.

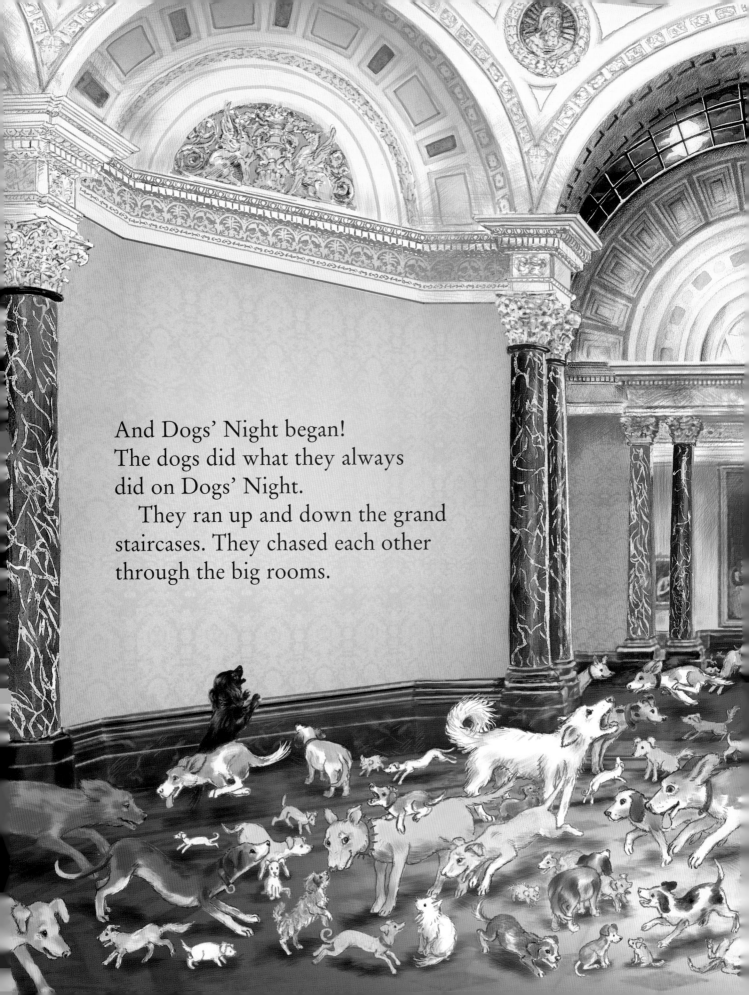

And Dogs' Night began!
The dogs did what they always
did on Dogs' Night.
 They ran up and down the grand
staircases. They chased each other
through the big rooms.

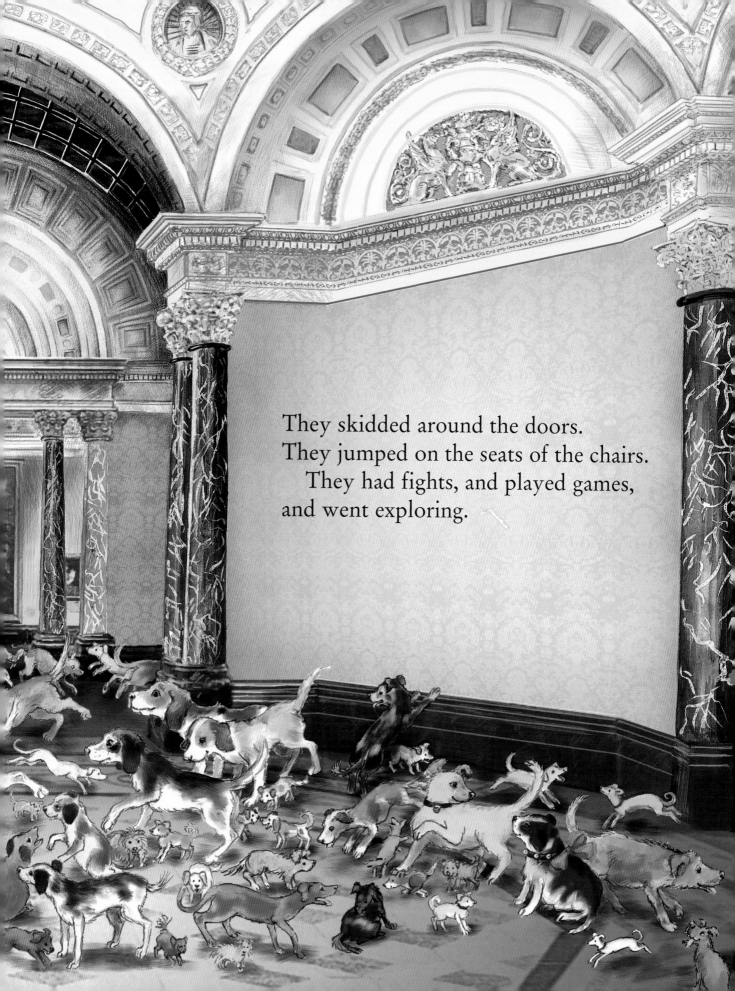

They skidded around the doors.
They jumped on the seats of the chairs.
 They had fights, and played games,
and went exploring.

But this Dogs' Night something was different.
The left-over food from the people's party was
still lying on the tables.

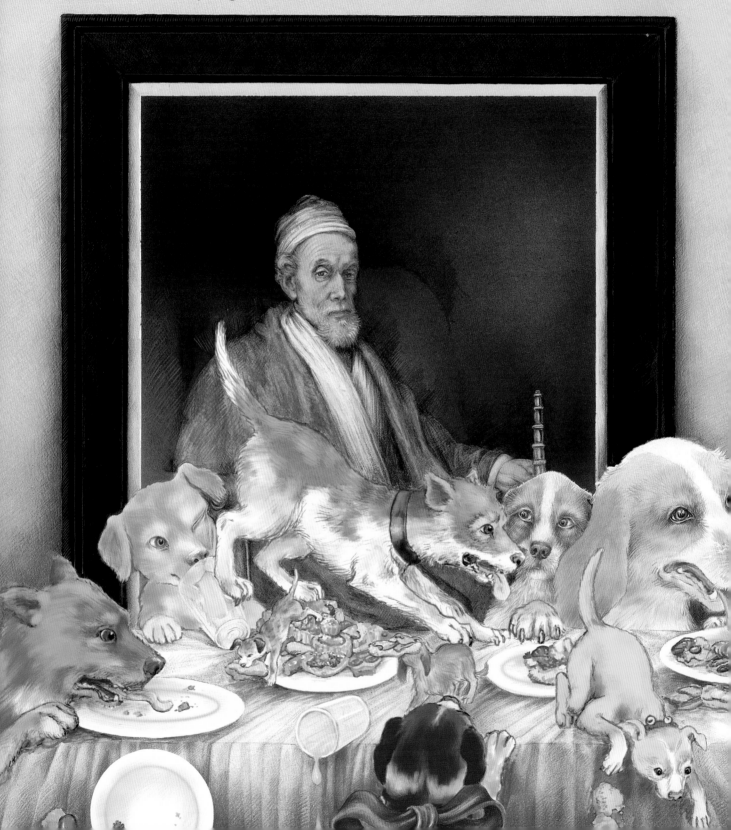

The dogs ate the cakes and the sandwiches.
They lapped up the fizzy drink.

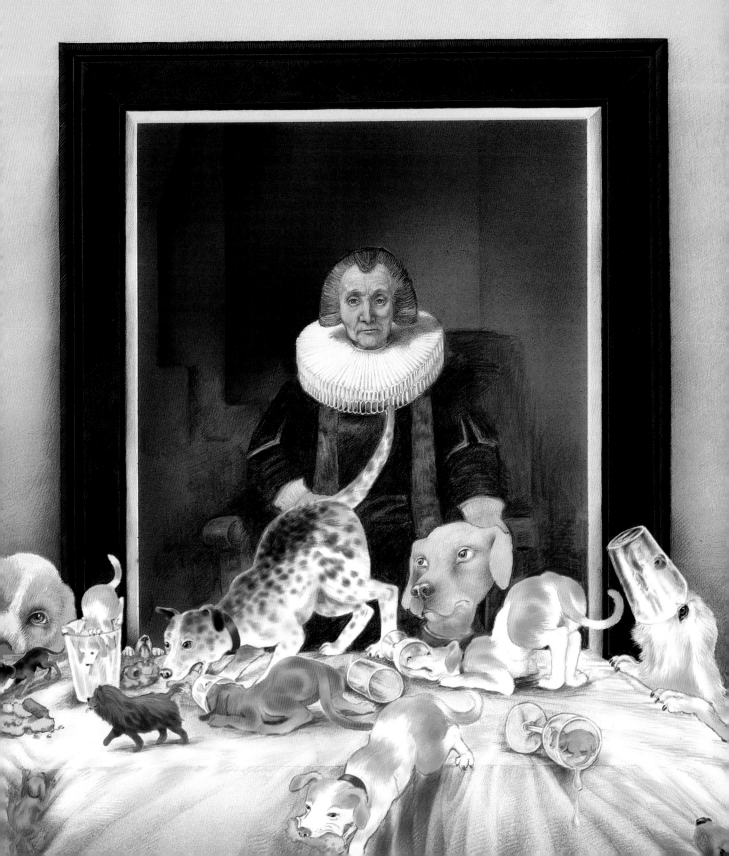

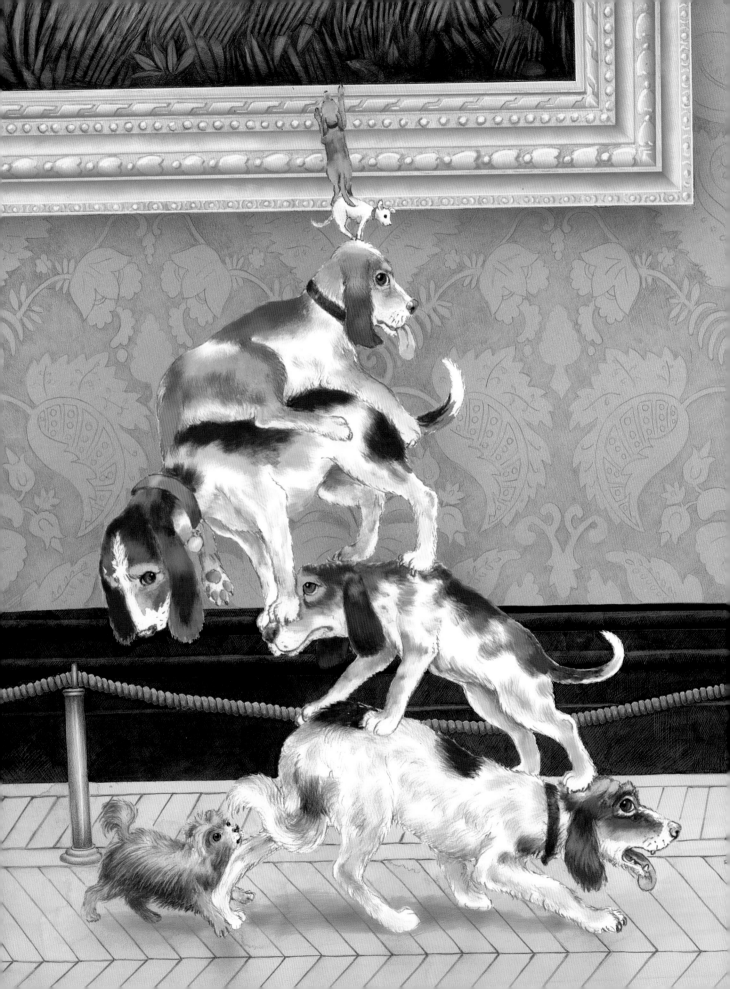

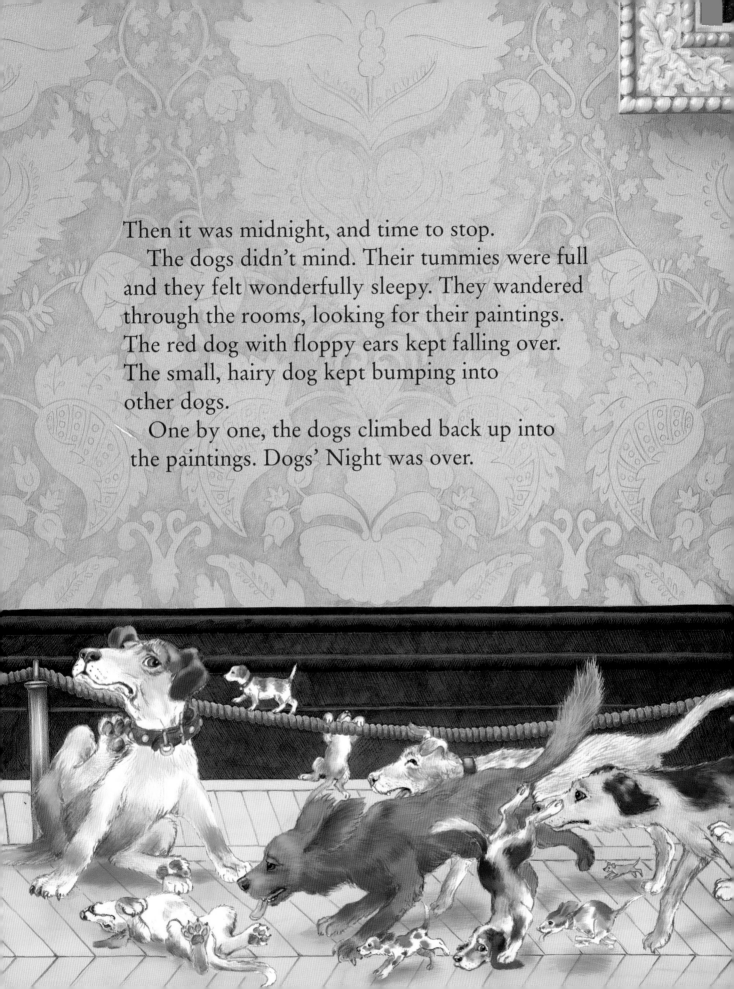

Then it was midnight, and time to stop.

The dogs didn't mind. Their tummies were full and they felt wonderfully sleepy. They wandered through the rooms, looking for their paintings. The red dog with floppy ears kept falling over. The small, hairy dog kept bumping into other dogs.

One by one, the dogs climbed back up into the paintings. Dogs' Night was over.

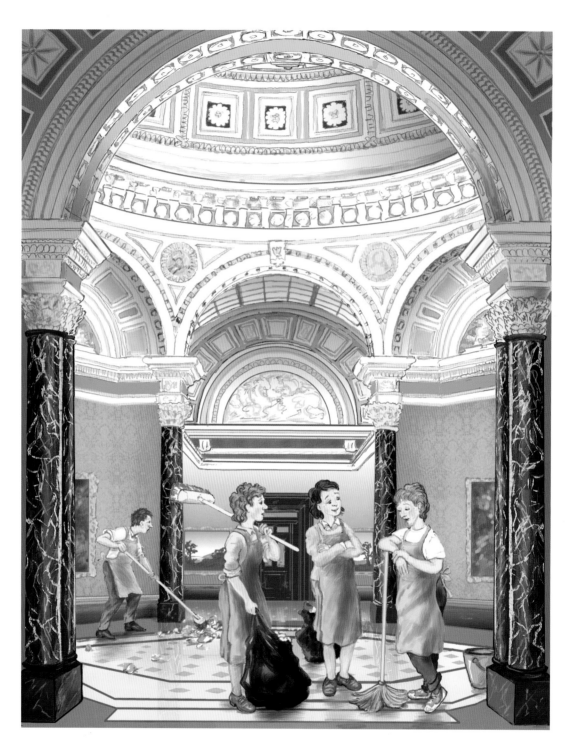

Next morning, very early, the cleaners arrived
and cleared away all the glasses and plates.
"What a mess," they grumbled.

At exactly ten o'clock the big front door of the Art Gallery was unlocked. People came in as they always did to look at the paintings.

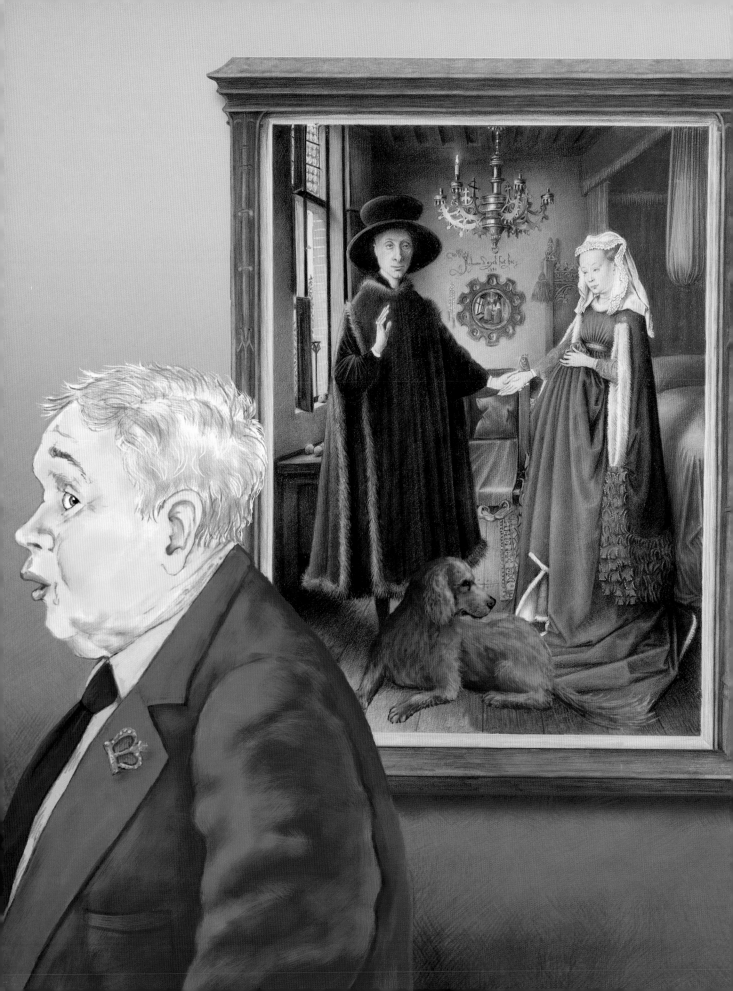

In the middle of the afternoon a little girl who was standing in front of a painting began to laugh.

"Sssh," said her teacher. A guard frowned. The girl laughed louder and louder.

"Oh look!" she said. "It's the wrong dog."

"Don't be so silly," said her teacher.

"It's the wrong dog," said the girl.

A guard was called, who found the Chief Warden, who asked for the Deputy Director, who ran to get the Director of the Art Gallery.

"Activate the alarms!" shouted the Director. "A most valuable painting has been stolen."

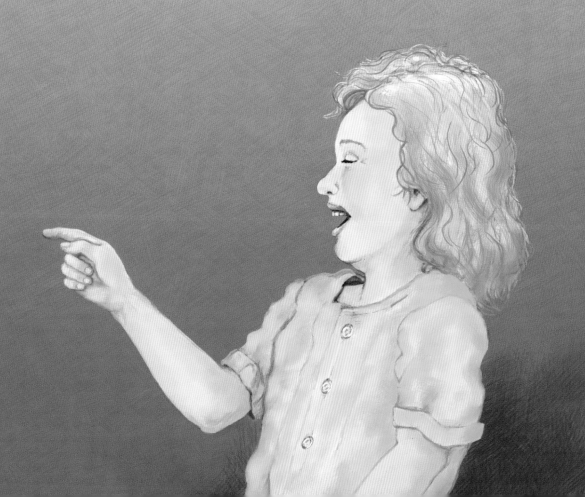

At that very moment an anxious tourist was staring at a painting in another room of the Art Gallery.

"Am I going mad?" said the tourist. "That dog. It does not belong!"

A guard was called, who found the Chief Warden, who ran to get the Deputy Director and the Director.

"What is happening?" roared the Director. "The dogs are in the wrong paintings. Search the Art Gallery!"

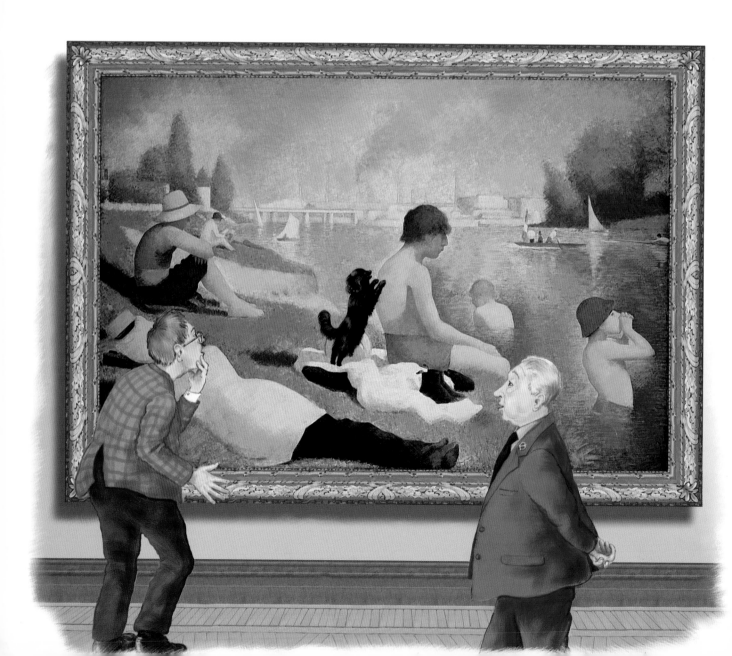

The guards, the Chief Warden, the Deputy Director and the Director all searched. And they found that there weren't just two paintings with the wrong dogs. There were four.

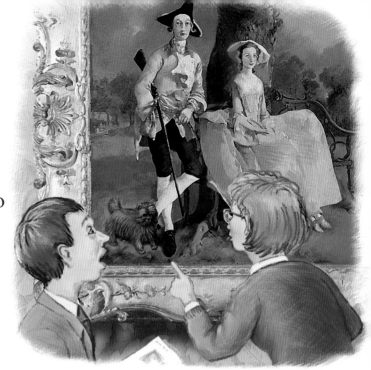

It was appalling. Disastrous. What could be done?

Experts examined the paintings. Nobody could work out how the dreadful thing had happened.

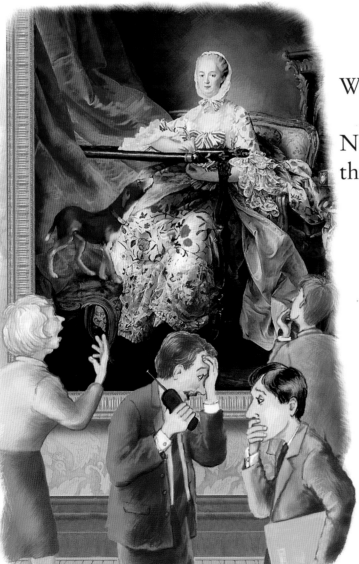

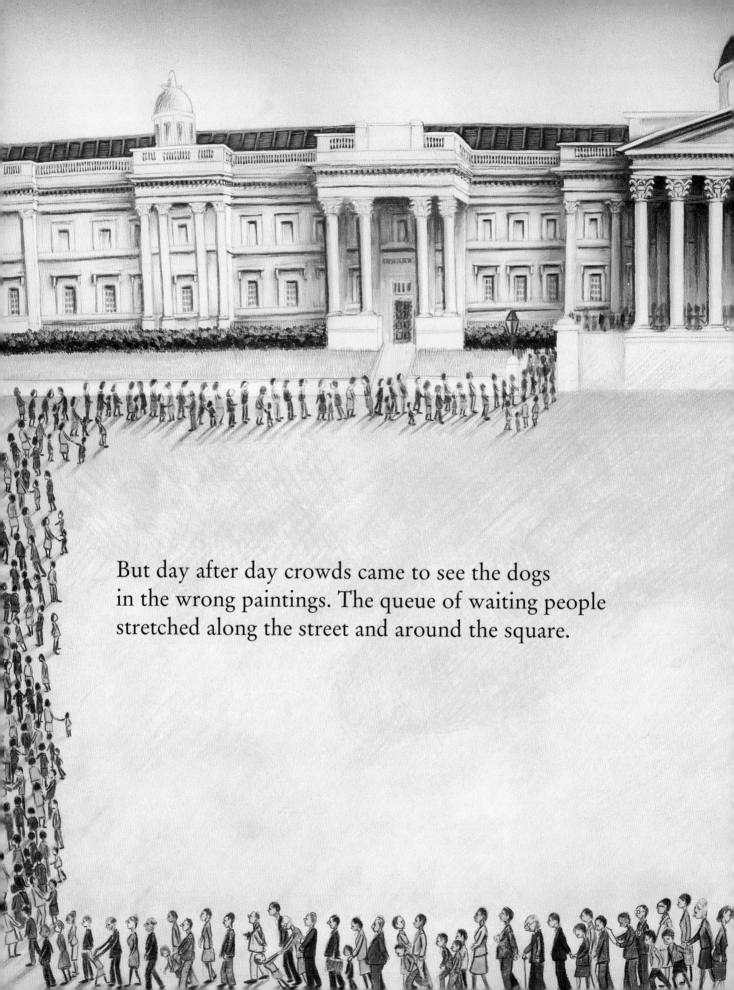

But day after day crowds came to see the dogs
in the wrong paintings. The queue of waiting people
stretched along the street and around the square.

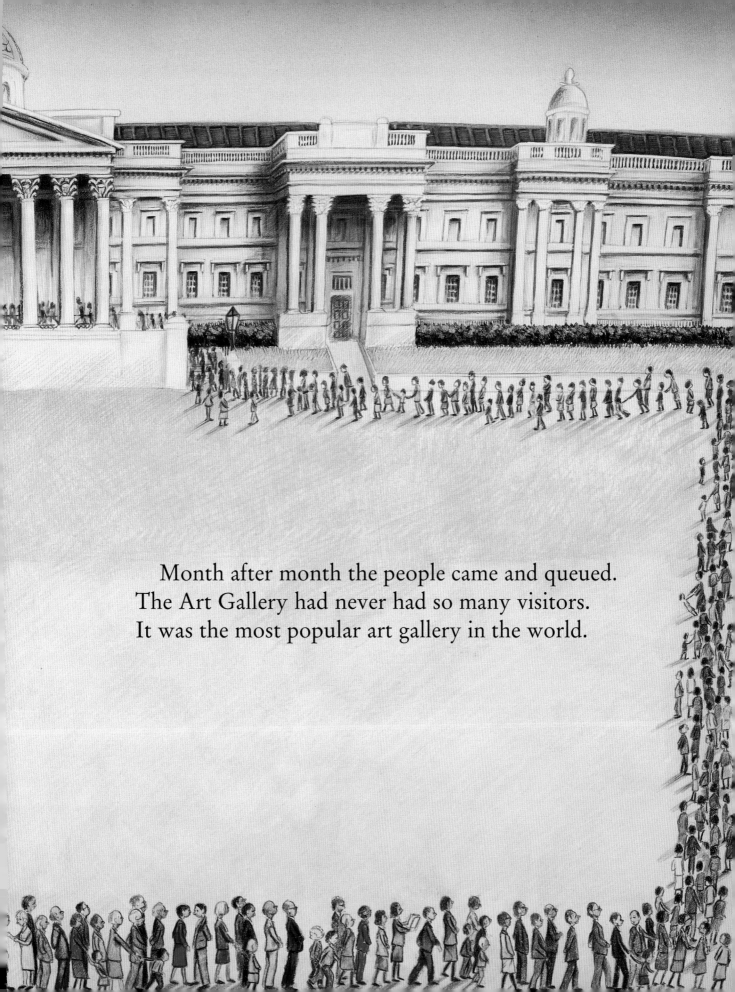

Month after month the people came and queued.
The Art Gallery had never had so many visitors.
It was the most popular art gallery in the world.

A year went by. It was Dogs' Night again, the dogs' secret, once a year, special night out. Nobody knew, of course. Only the dogs knew, waiting in the paintings, noses sniffing the air, ears listening for the time when everyone had gone home and they had the Art Gallery to themselves.

The dogs in the wrong paintings felt very uncomfortable. They could not wait to get out, and climb down onto the shiny floor.

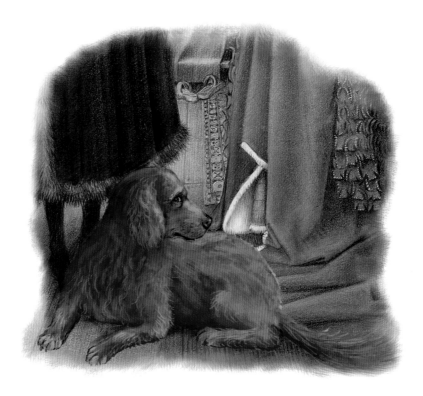

The red dog with floppy ears
was bored with being in a bedroom.

The black dog with the wavy tail was tired of being by the river.

The big, brown hunting dog with the white nose hated standing on a chair.

The small, hairy dog was scared of guns.

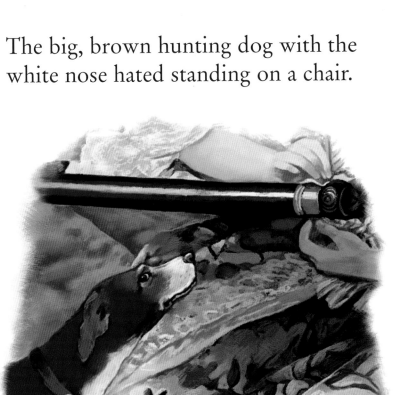

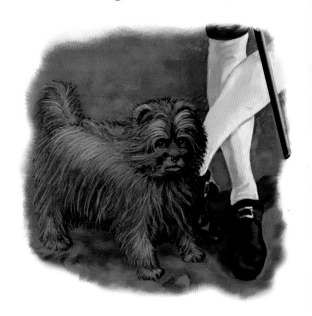

At last it was closing time. The guards checked that there was no one left in any of the rooms. They shut the doors of the Art Gallery and locked them. Everything was quiet and empty.

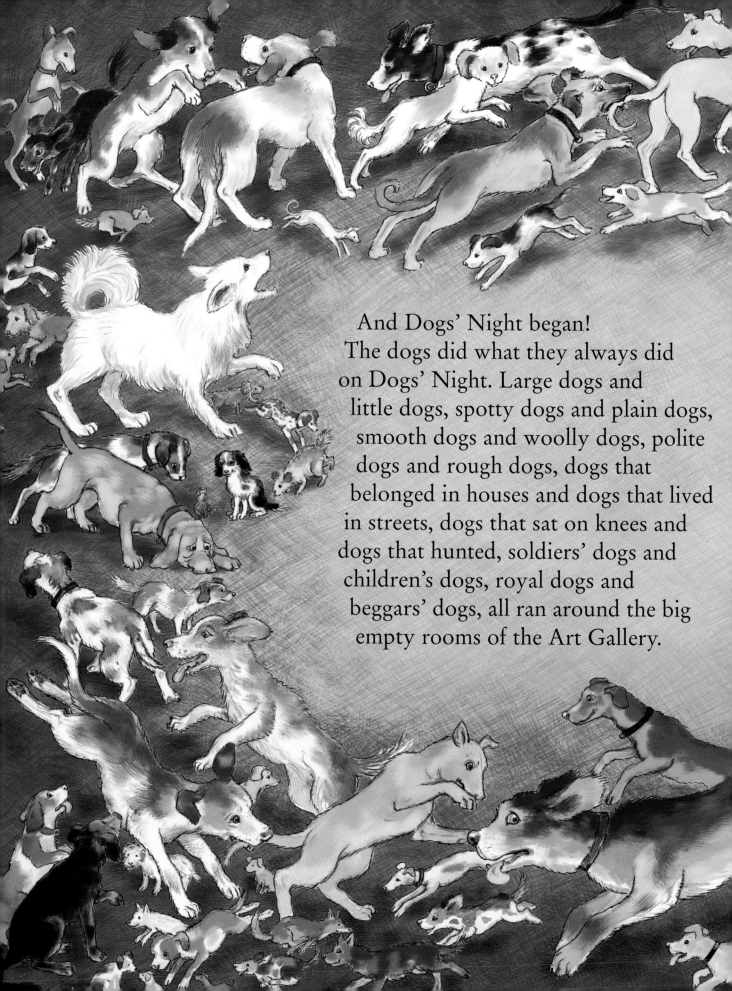

And Dogs' Night began!
The dogs did what they always did
on Dogs' Night. Large dogs and
little dogs, spotty dogs and plain dogs,
smooth dogs and woolly dogs, polite
dogs and rough dogs, dogs that
belonged in houses and dogs that lived
in streets, dogs that sat on knees and
dogs that hunted, soldiers' dogs and
children's dogs, royal dogs and
beggars' dogs, all ran around the big
empty rooms of the Art Gallery.

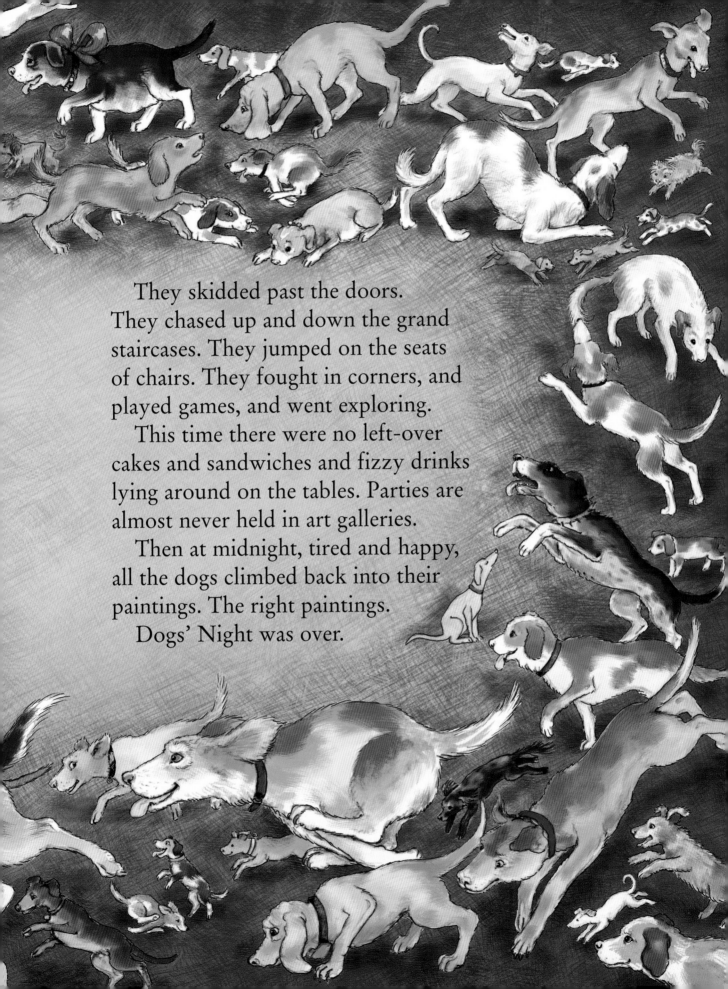

They skidded past the doors.
They chased up and down the grand
staircases. They jumped on the seats
of chairs. They fought in corners, and
played games, and went exploring.

This time there were no left-over
cakes and sandwiches and fizzy drinks
lying around on the tables. Parties are
almost never held in art galleries.

Then at midnight, tired and happy,
all the dogs climbed back into their
paintings. The right paintings.

Dogs' Night was over.

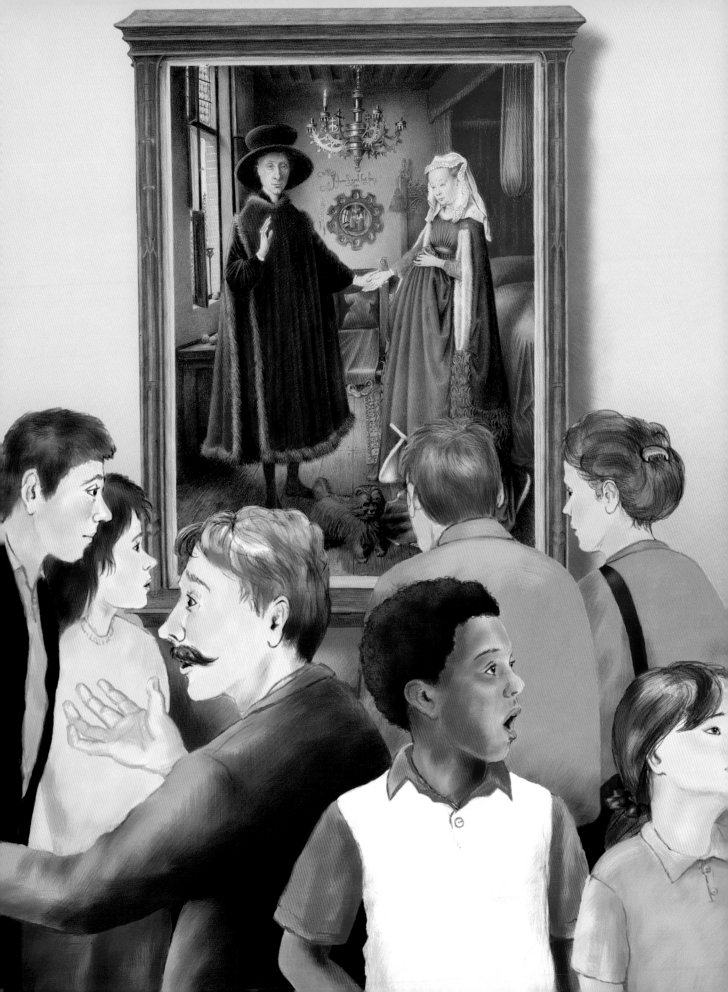

Next morning the crowds came rushing in as soon as the
Art Gallery was open, to see the dogs in the wrong paintings.
But the dogs were in the right paintings.

No one could understand how it had happened.
It was one of the great mysteries. Experts came from around
the world. Scholars wrote books. Television programmes
were made.

The dogs knew, of course.

But Dogs' Night was their secret.

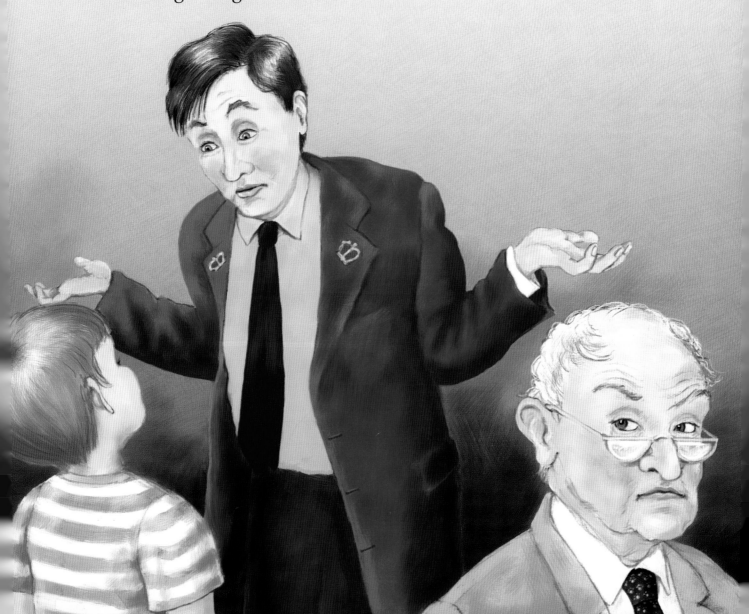

About the Paintings

Look at a collection of paintings, and you will nearly always find some dogs – sniffing, eating, jumping up, or standing right in the middle of a painting, staring out. Dogs of every shape and size and colour: paws on tables, checking bones, stealing from humans, belonging to humans.

Wherever you live, you can find dogs in paintings. Every art gallery has its dogs, eagerly waiting for Dogs' Night.

The dogs who climb back into the wrong paintings in this book are all from the National Gallery in London.

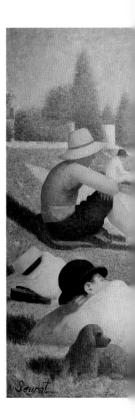

❖ The small, hairy dog is in *The Portrait of Giovanni Arnolfini and his Wife, Giovanna Cenami* ('The Arnolfini Marriage'), painted by Jan van Eyck in 1434.
❖ The brown hunting dog with the white nose is in *Mr and Mrs Andrews*, painted by Thomas Gainsborough in about 1748-9.
❖ The black dog with the wavy tail is in *Madame de Pompadour*, painted by François-Hubert Drouais in 1763-4.
❖ The red dog with floppy ears is in *Bathers at Asnières*, painted by Georges-Pierre Seurat in 1884.

The other dogs in the book come from paintings in the National Gallery as well. If you go there and look, you might find some of them.

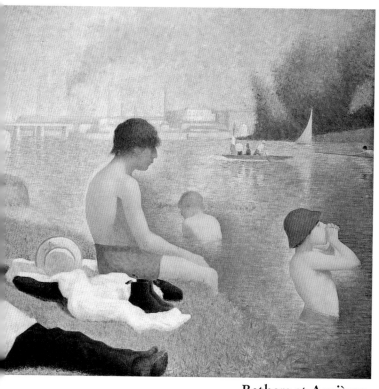

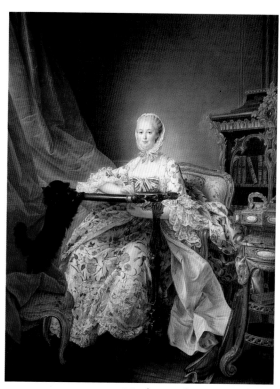

Bathers at Asnières

Madame de Pompadour

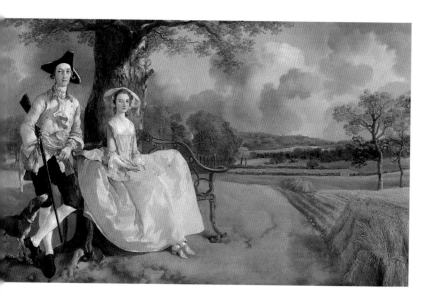

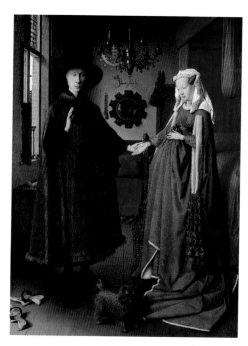

Mr and Mrs Andrews

The Portrait of Giovanni
Arnolfini and his Wife,
Giovanna Cenami

MORE TITLES BY MEREDITH HOOPER FROM FRANCES LINCOLN CHILDREN'S BOOKS

Celebrity Cat
With paintings from art galleries around the world
Illustrated by Bee Willey

It is Cats' Visiting Night at the Art Gallery and all the city's cats
are gathering to look at cat paintings. But where are they?
There are paintings of dogs, birds, tigers, even fish – but hardly
a painted cat to be seen! Felissima Cat ponders the problem
back in her studio, and decides to put the cats
where they rightly belong…

ISBN 1-84507-290-1

Honey Biscuits
Honey Cookies (USA)
Illustrated by Alison Bartlett

One cow? A thousand buzzing bees? The bark from a tree?
When Ben learns how to make cookies with his gran,
he doesn't just find out how to bake biscuits, he also
discovers where all the ingredients come from
and whose help he really needs.

ISBN 1-84507-045-3 (UK)
ISBN 1-84507-395-9 (USA)

Tom Crean's Rabbit
A True Story from Scott's Last Voyage
Illustrated by Bert Kitchen

It's very cold in Antarctica, and the *Terra Nova* is crowded
with animals and men. Tom the sailor is looking for a quiet,
cosy place for his pet rabbit. High in the rigging, down in the hold –
where can little rabbit make her nest?

ISBN 1-84507-393-2

Frances Lincoln titles are available from all good bookshops.
You can also buy books and find out more about your favourite titles,
authors and illustrators on our website: www.franceslincoln.com